This book belongs to

..

Followthemoonart.com
New Hampshire
Copyright 2019 All rights reserved

All rights reserved. No part of this book may be reproduced or used in any form or by any means, electronic, mechanical, digital or hard copy without permission in writing from the publisher Followthemoonart. Copyright 2019

ISBN- 9781094733258
Imprint: Independently published

Cover and book design by S. Pimental

Cats, Rabbits & Roses

COLORING BOOK

Illustrated by
Sylvia Pimental

Followthemoonart.com
All rights reserved COPYRIGHT 2019

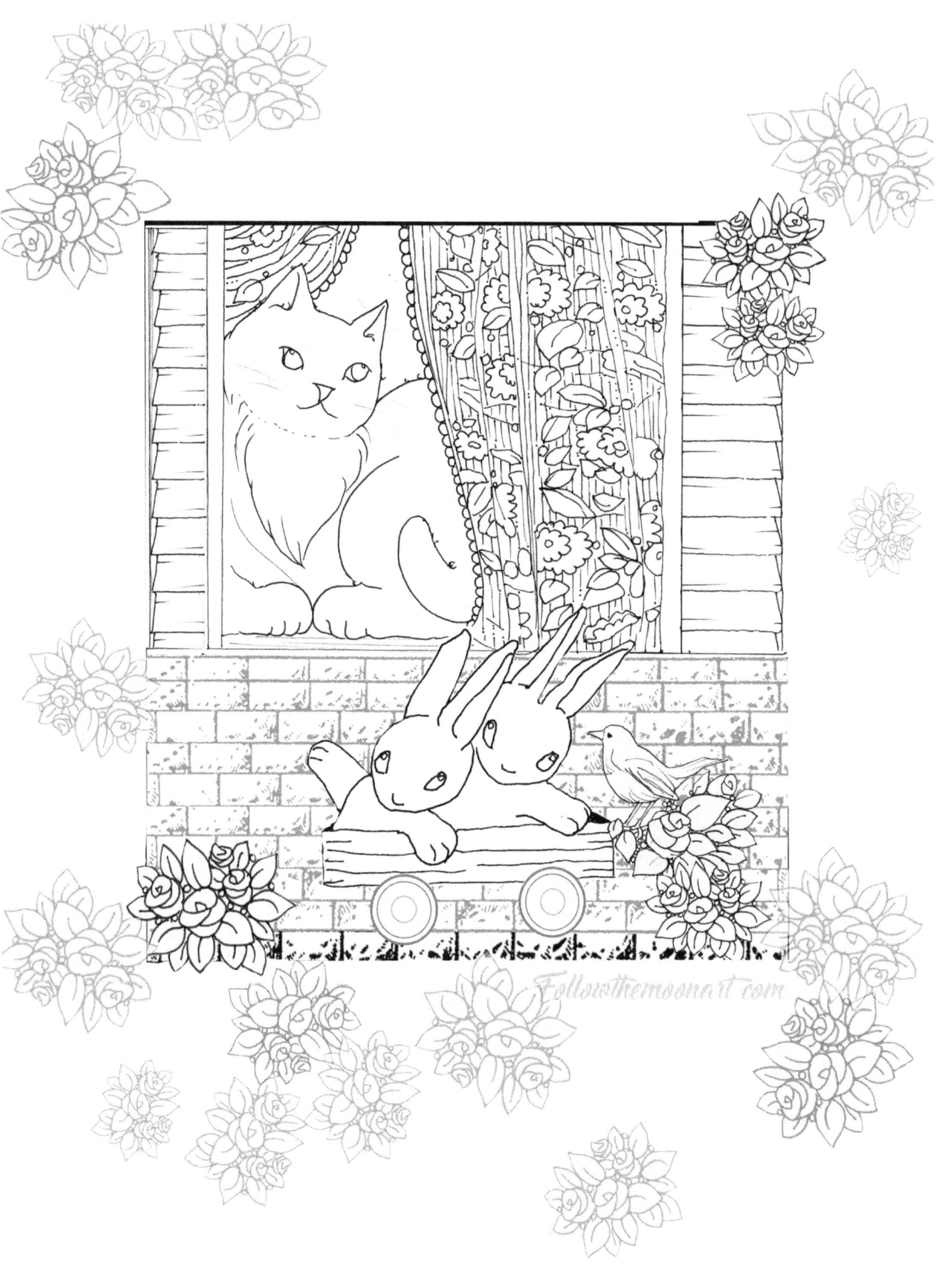

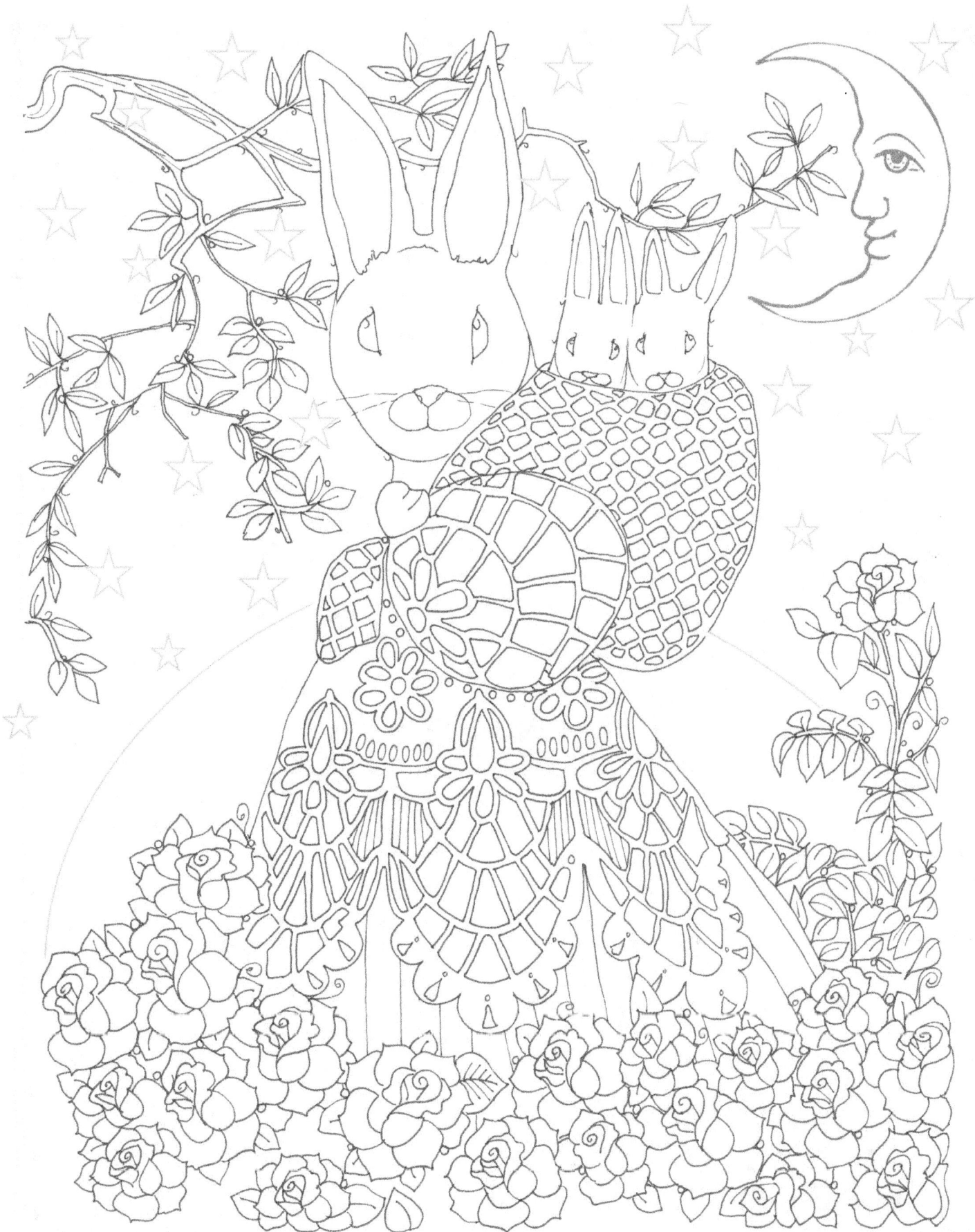

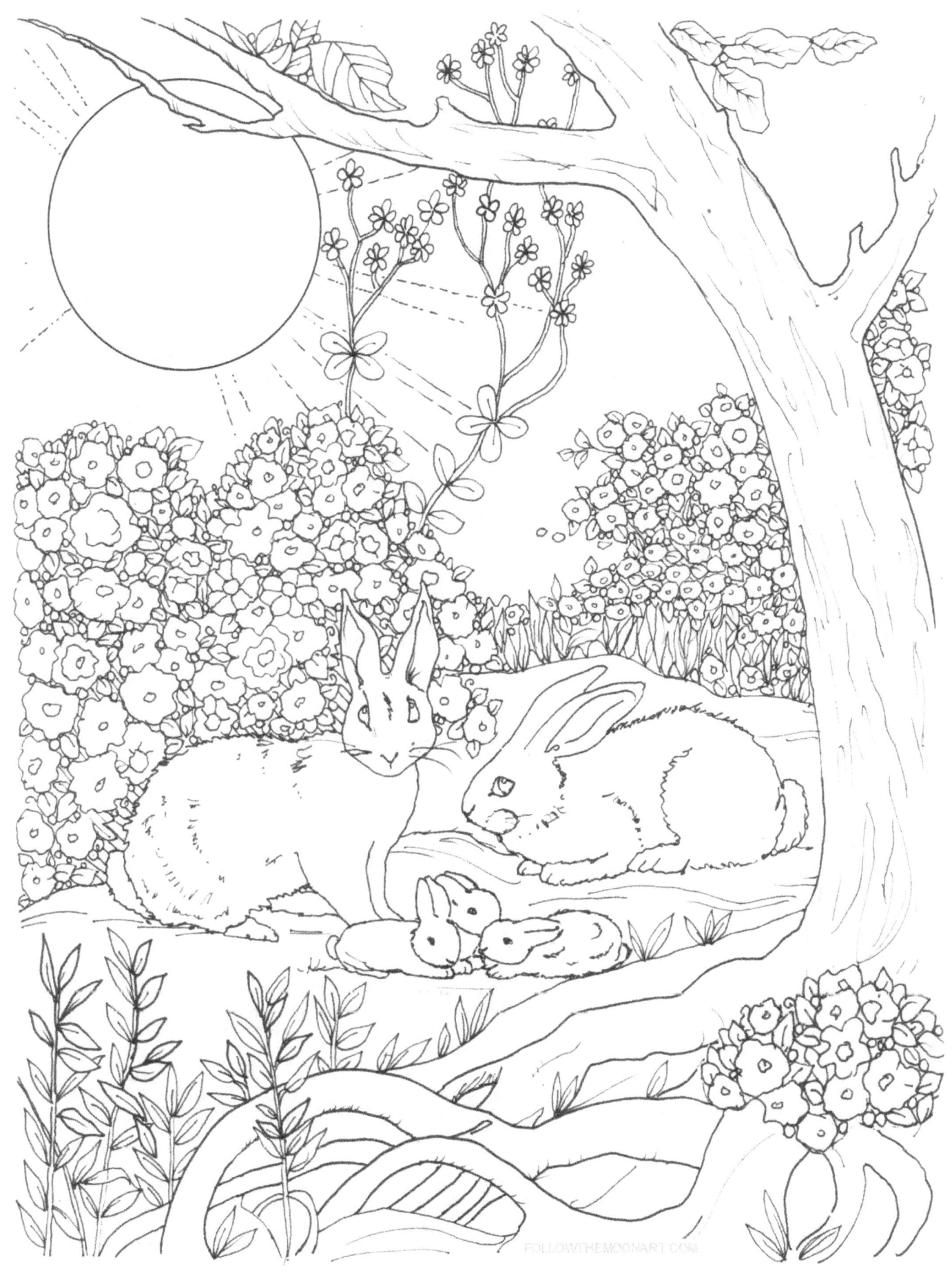

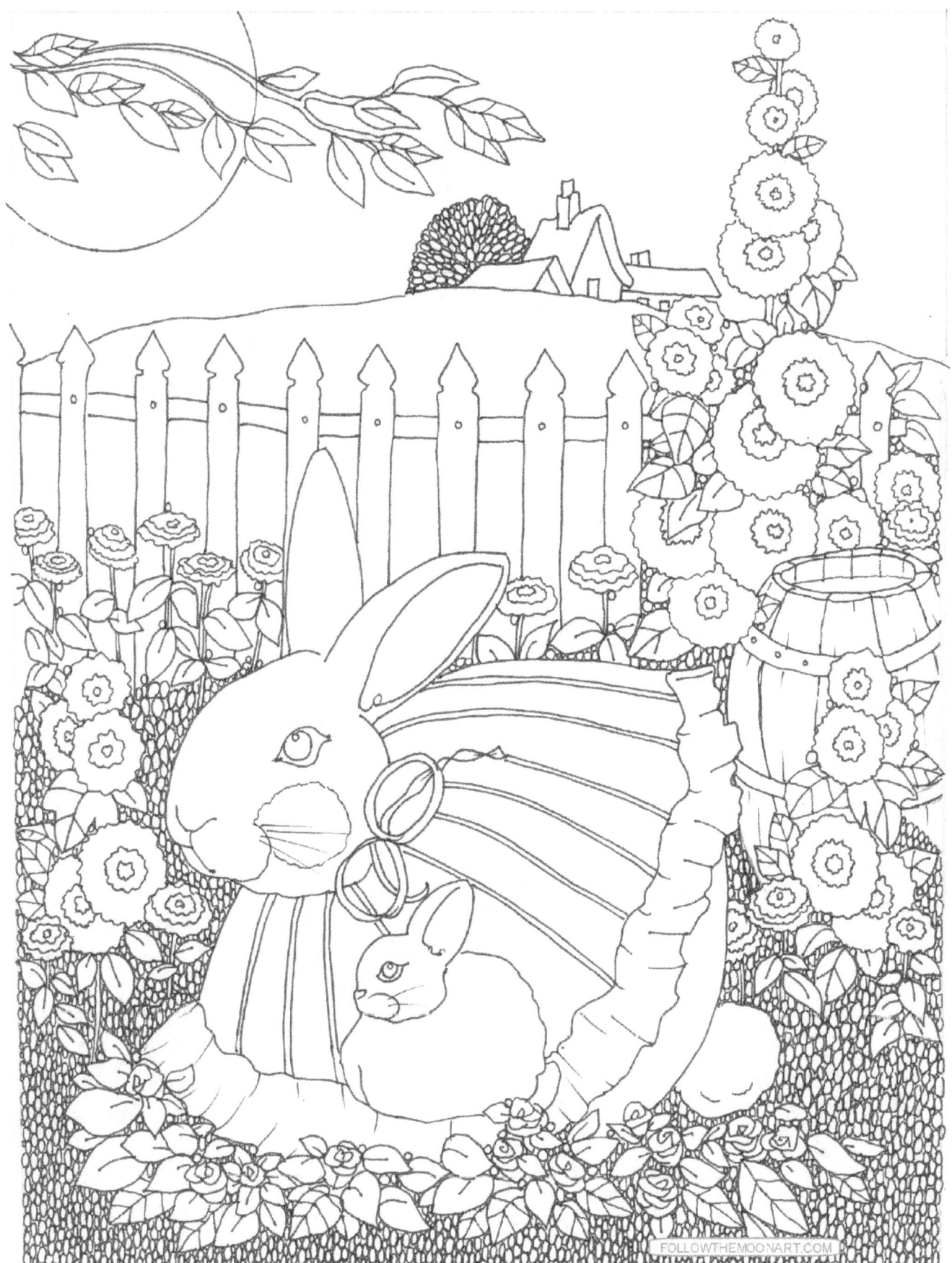

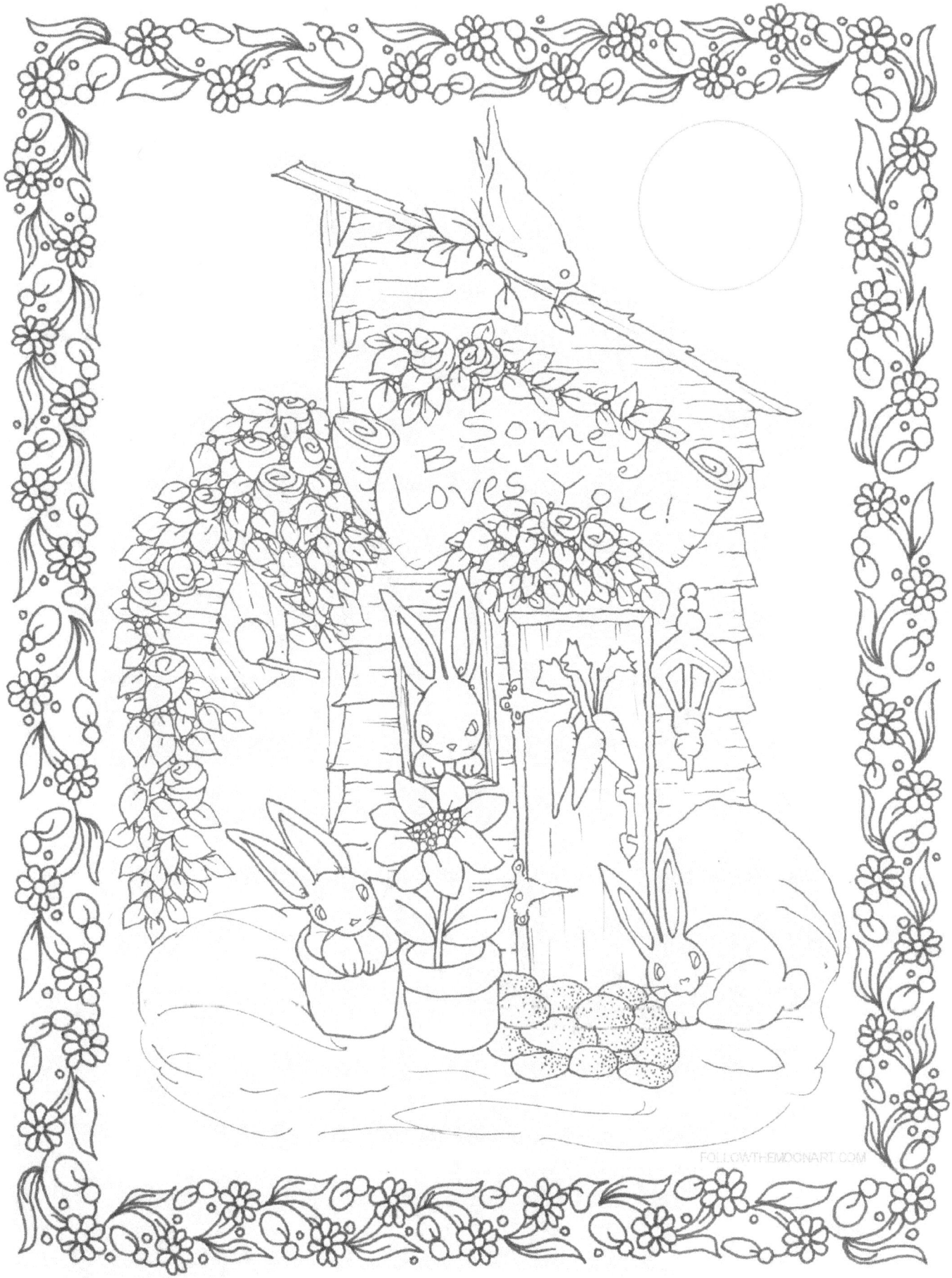

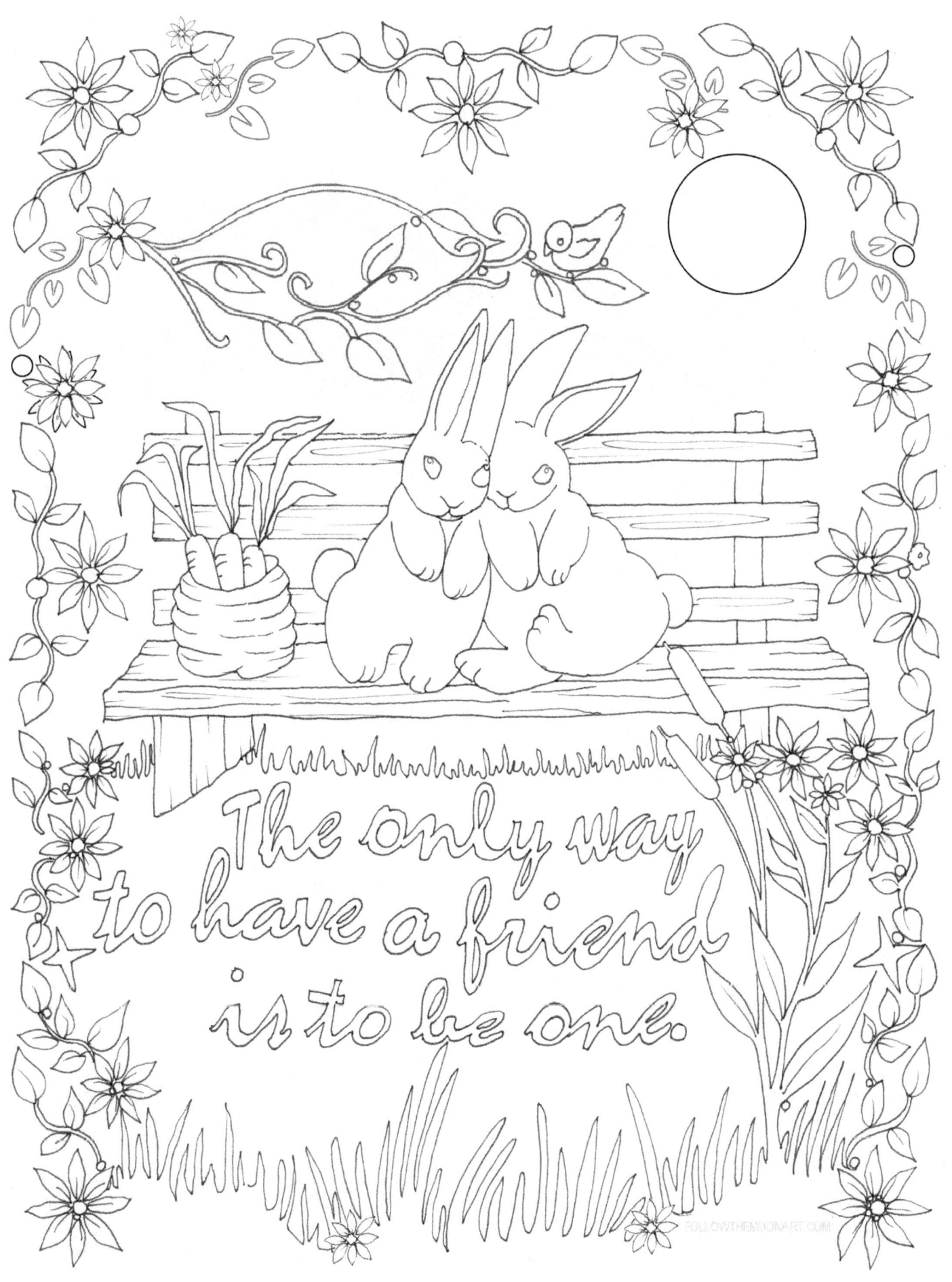

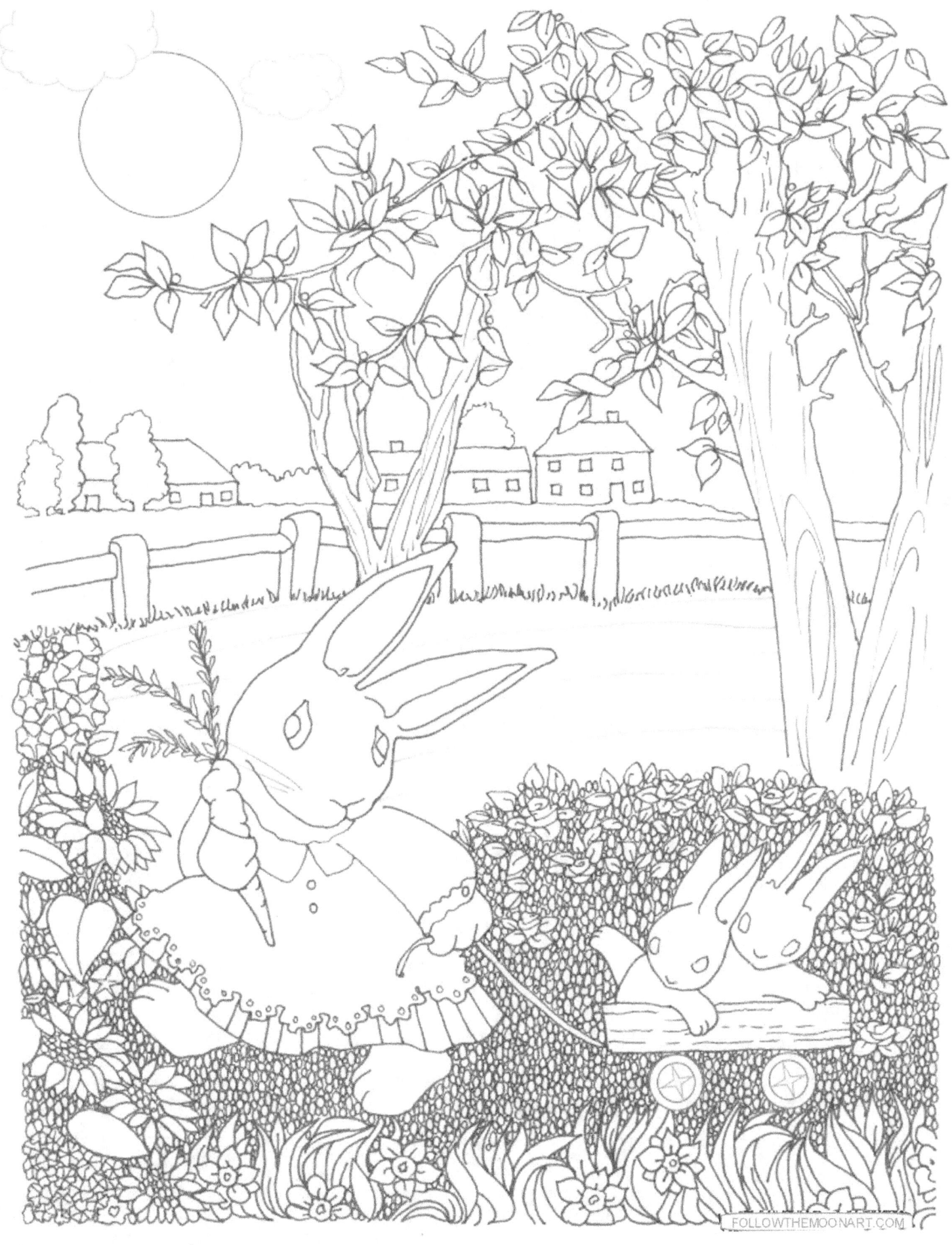

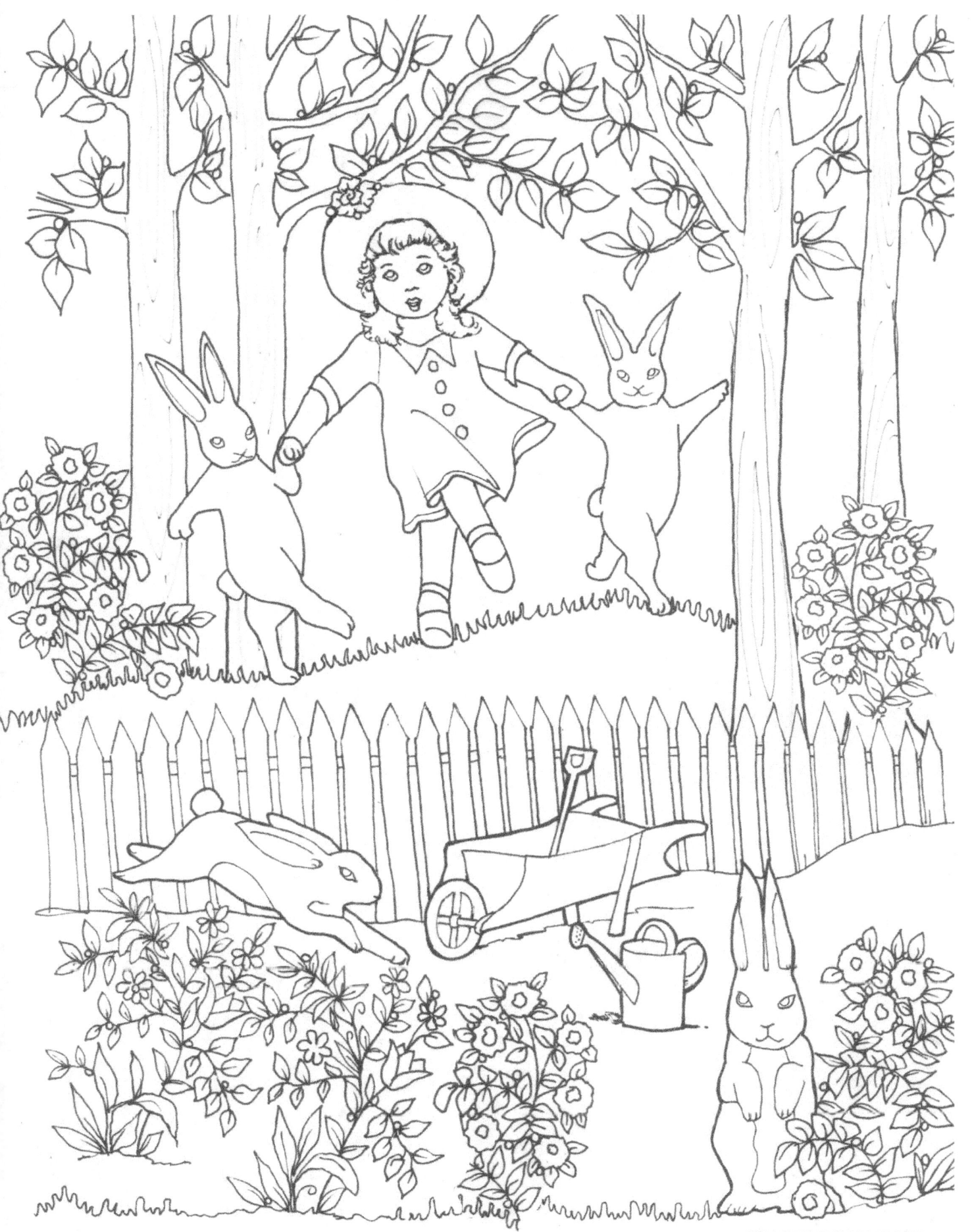

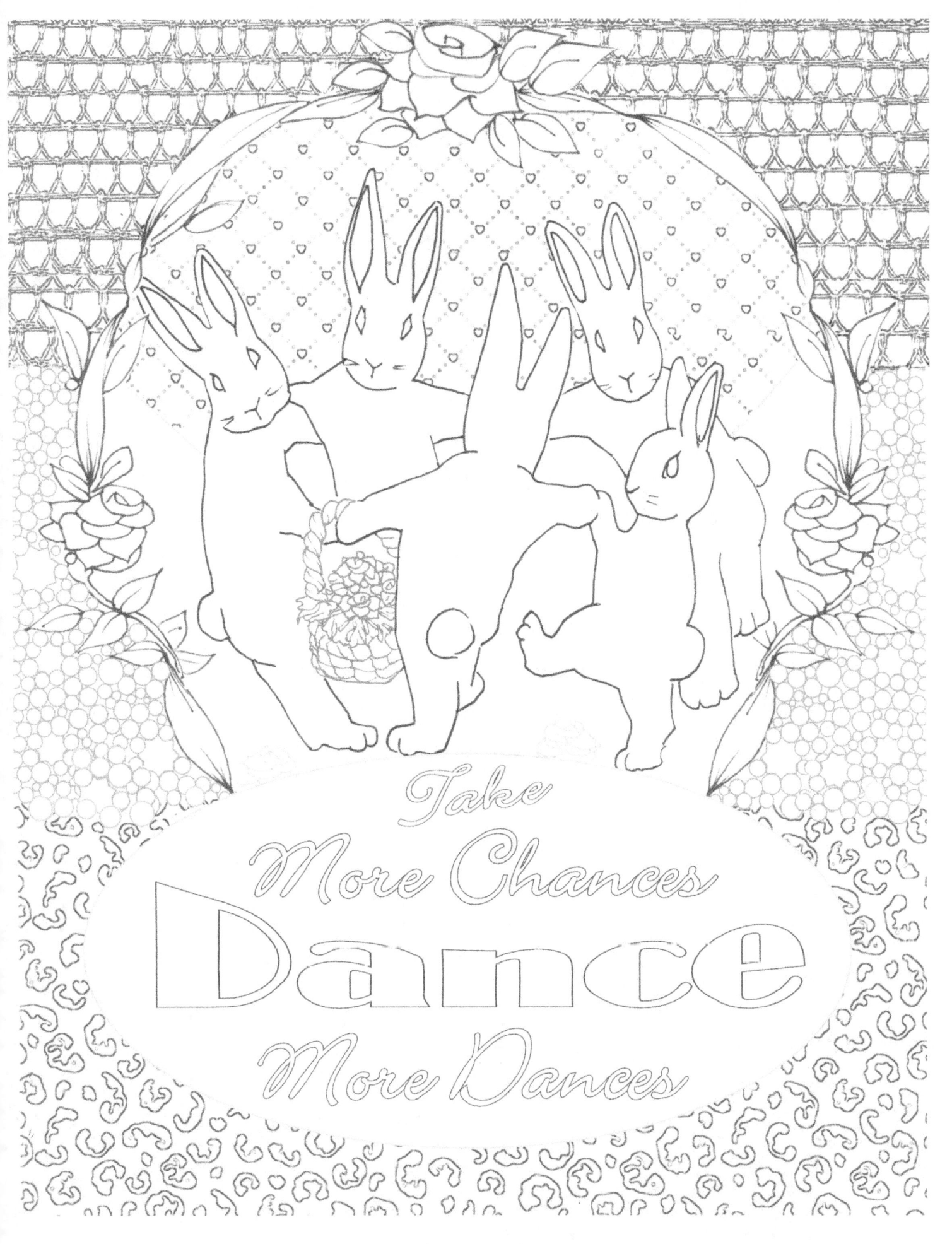

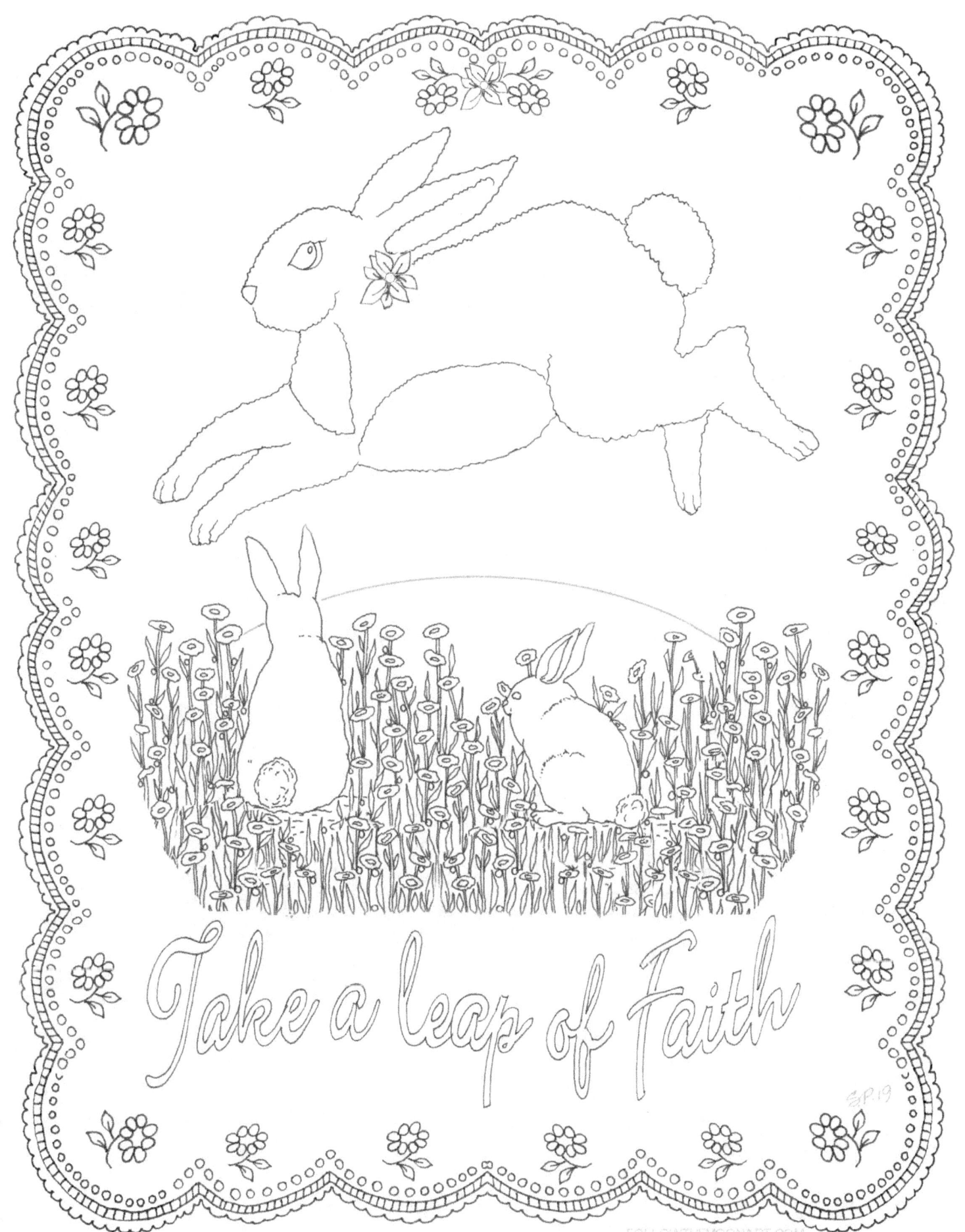

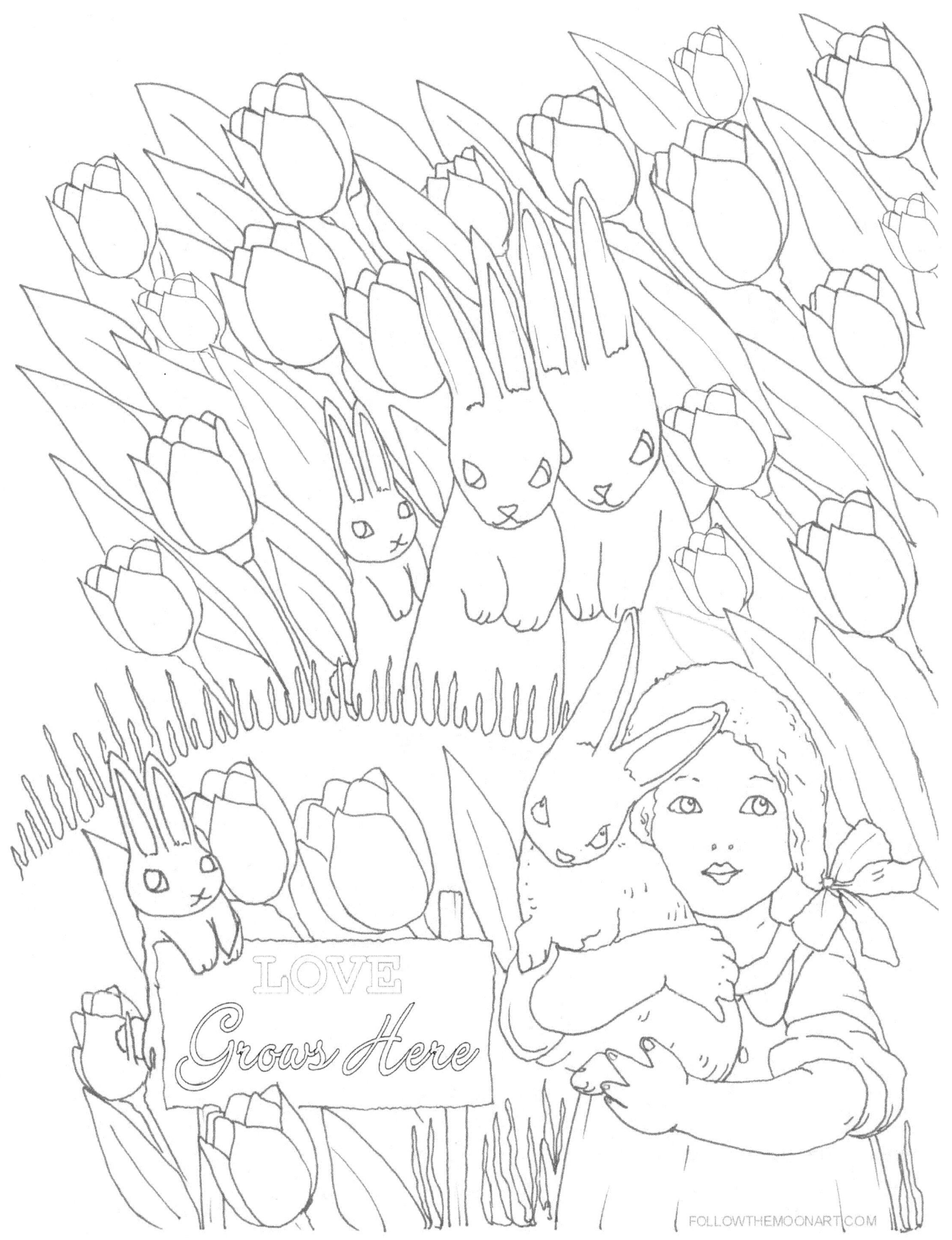

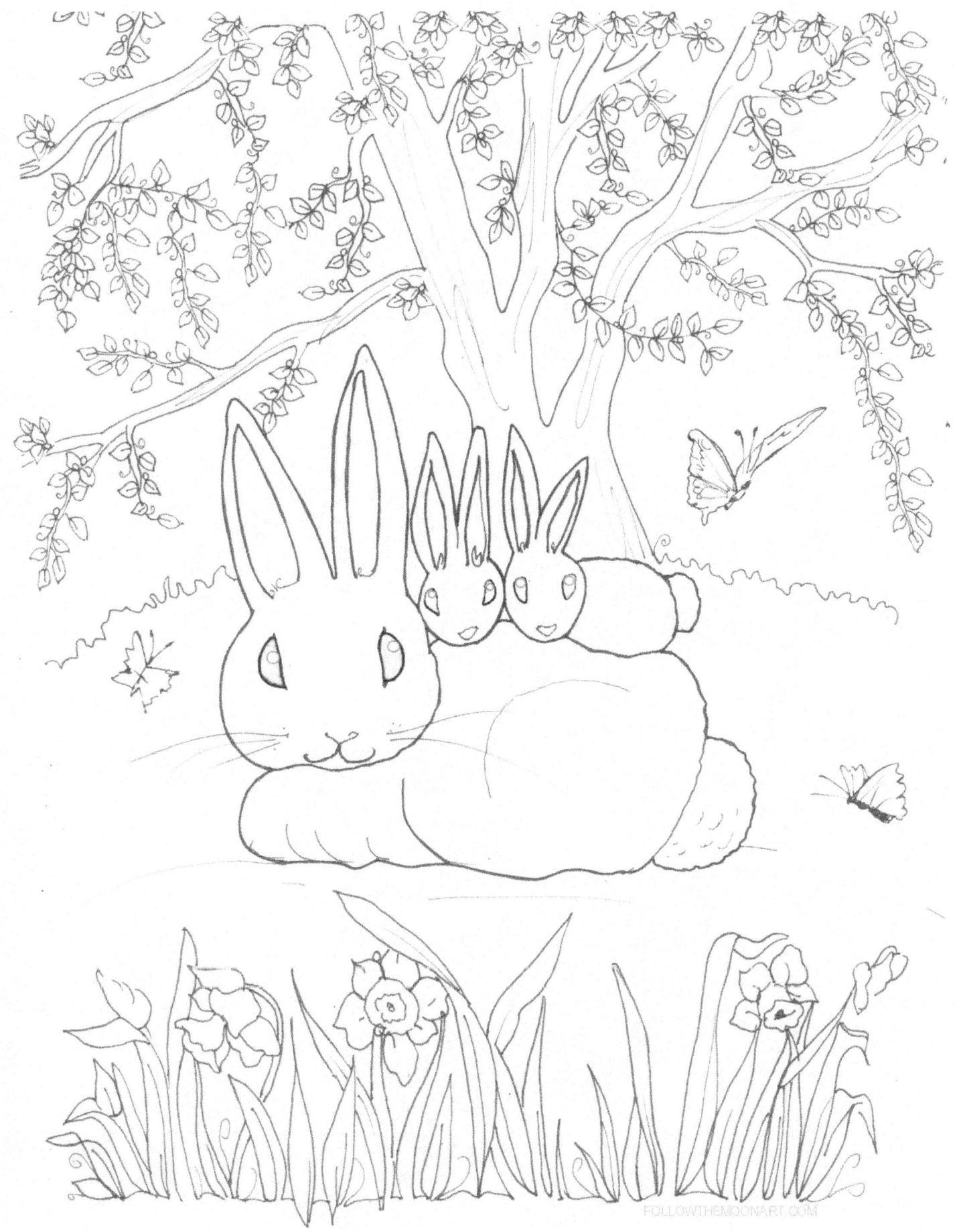

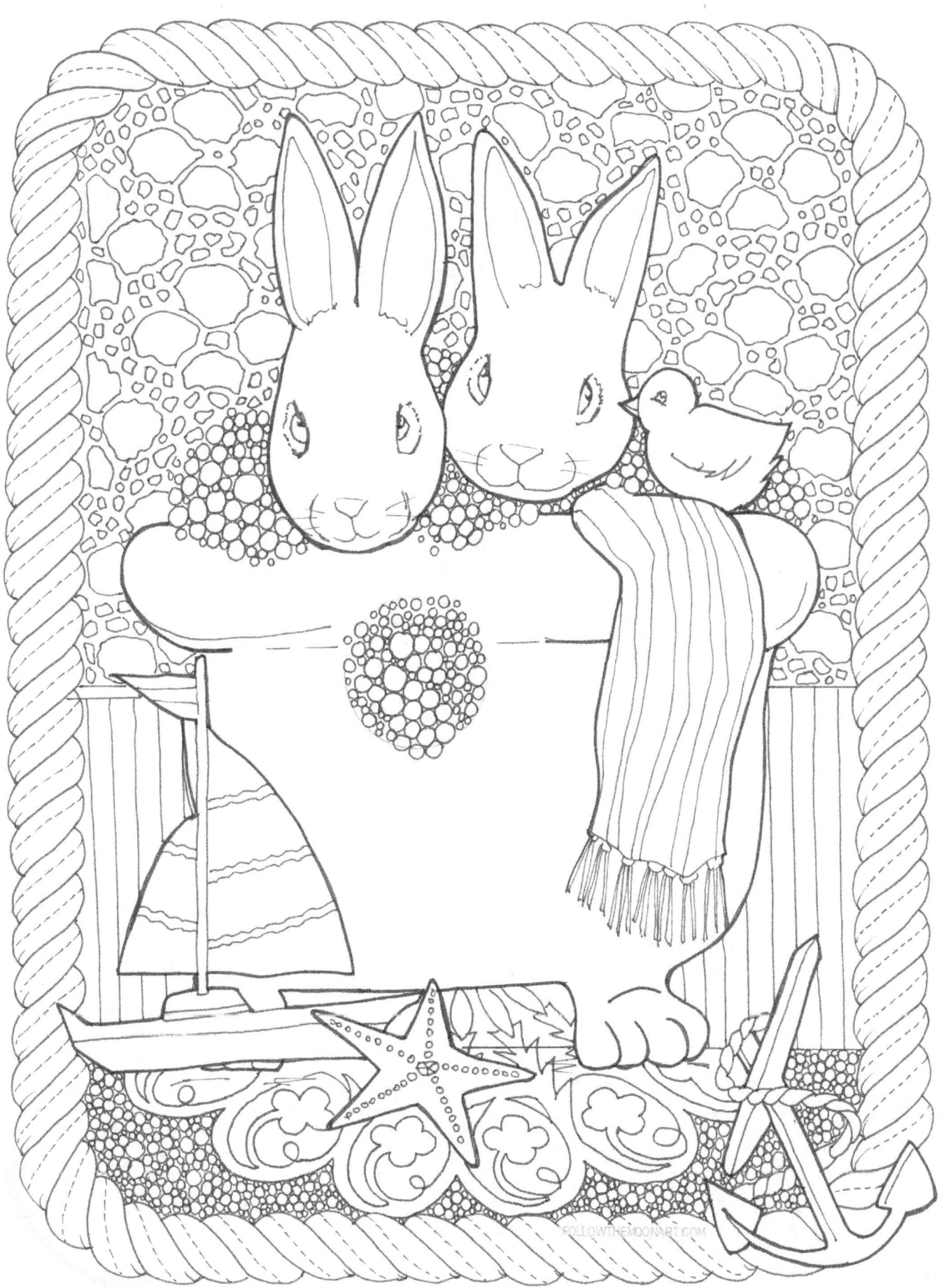

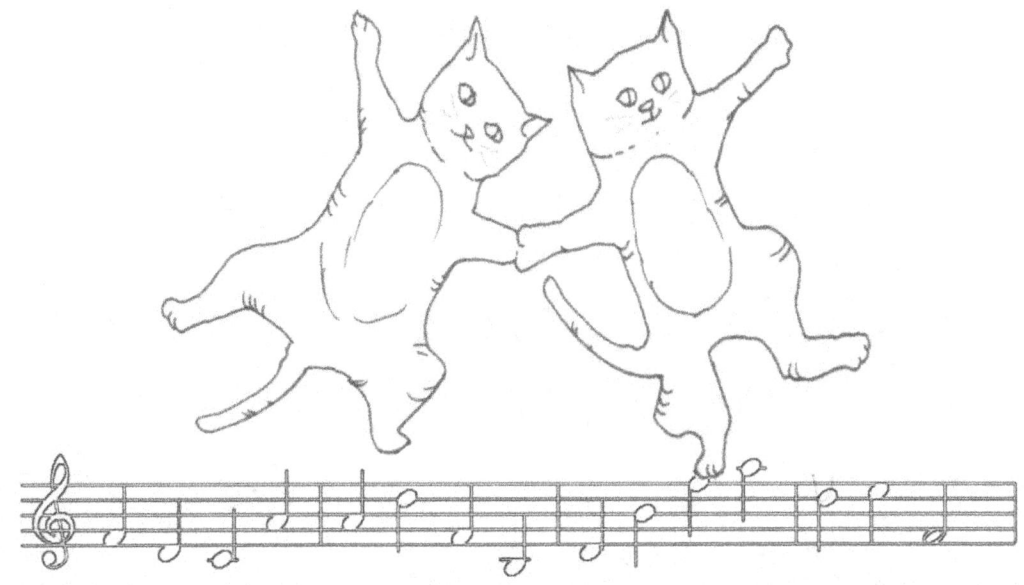

Listen to Good Music

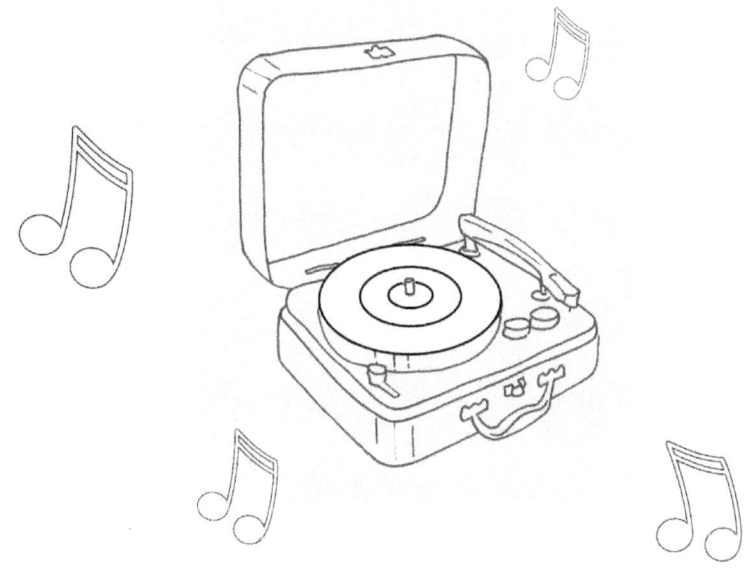

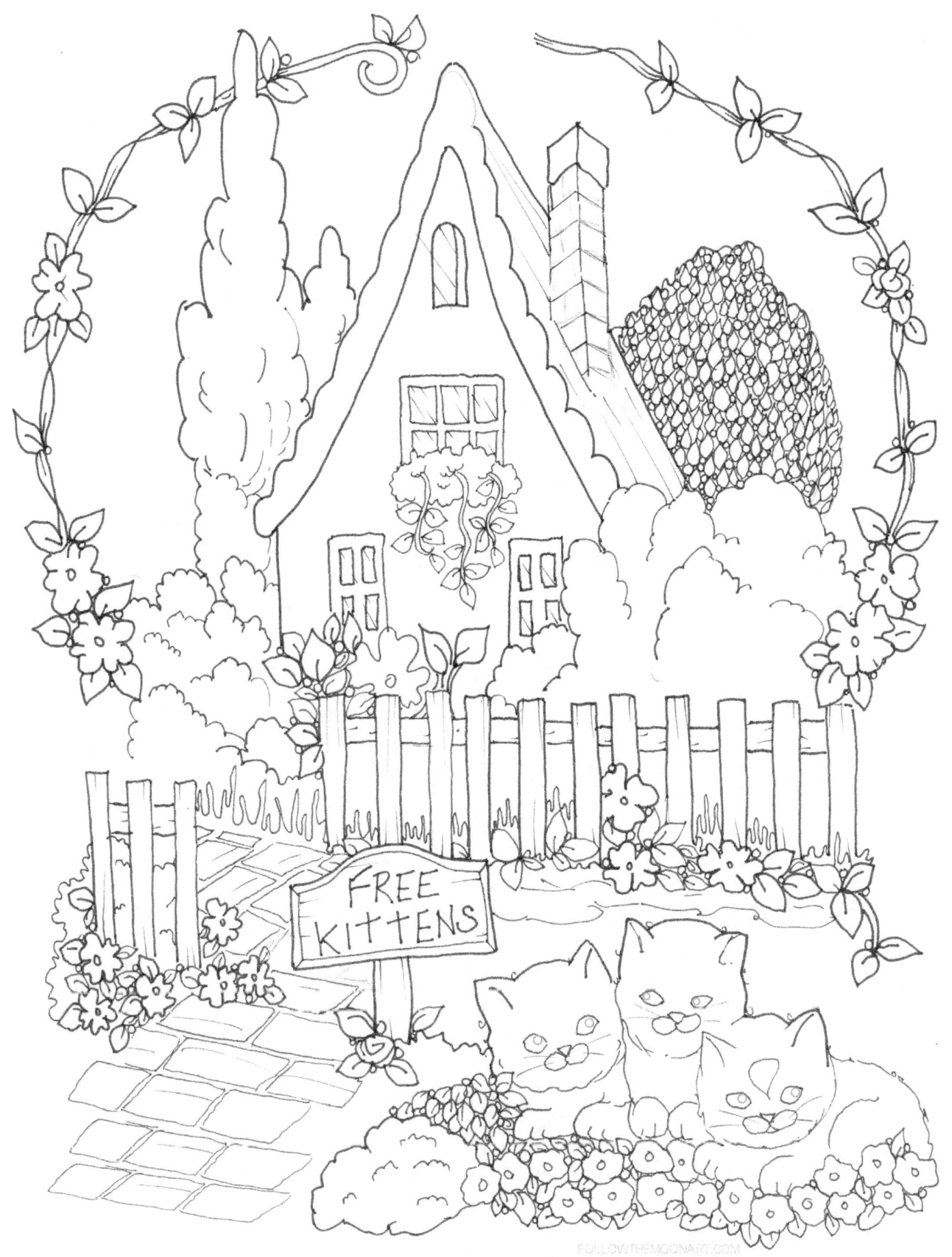

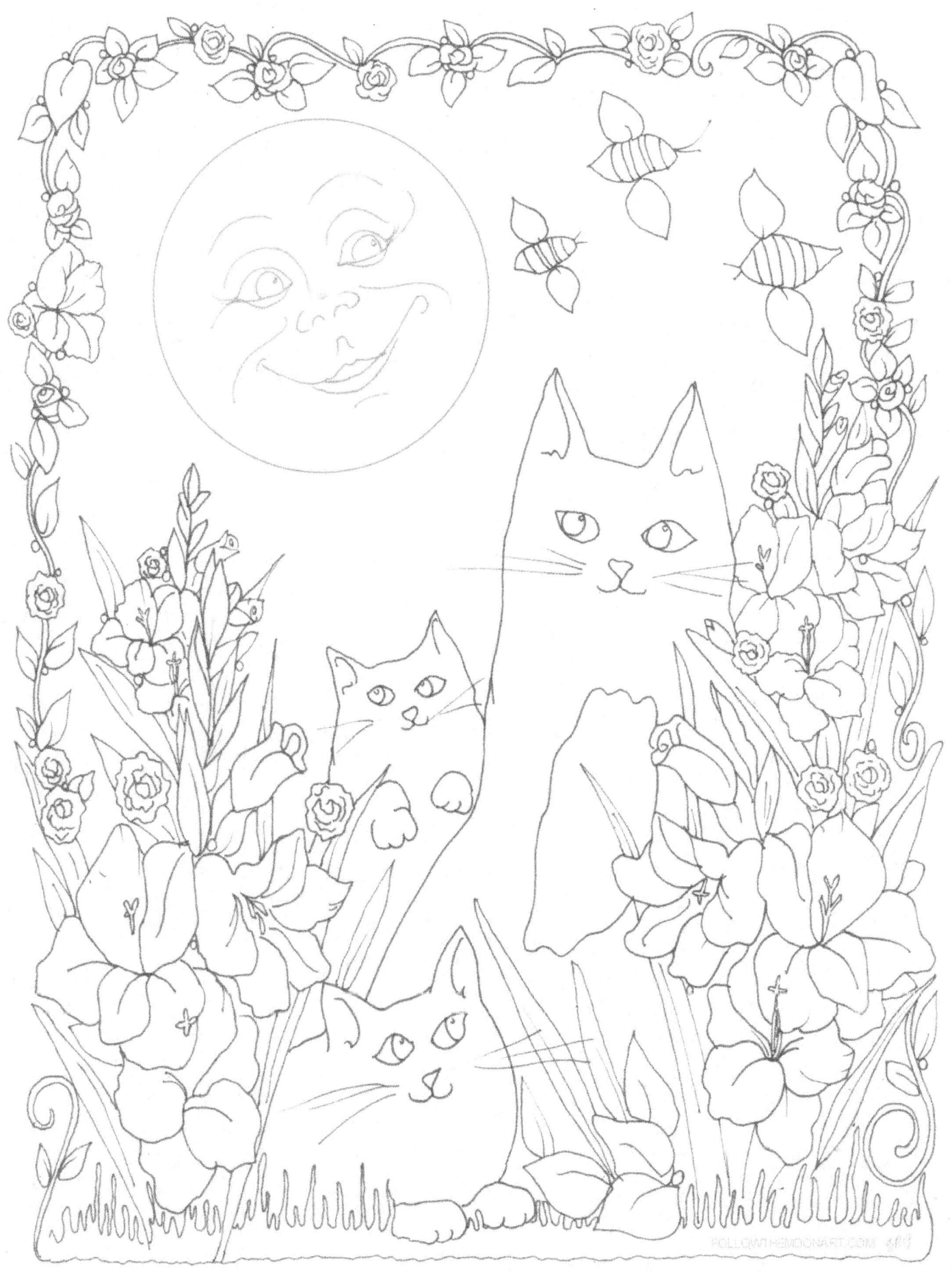

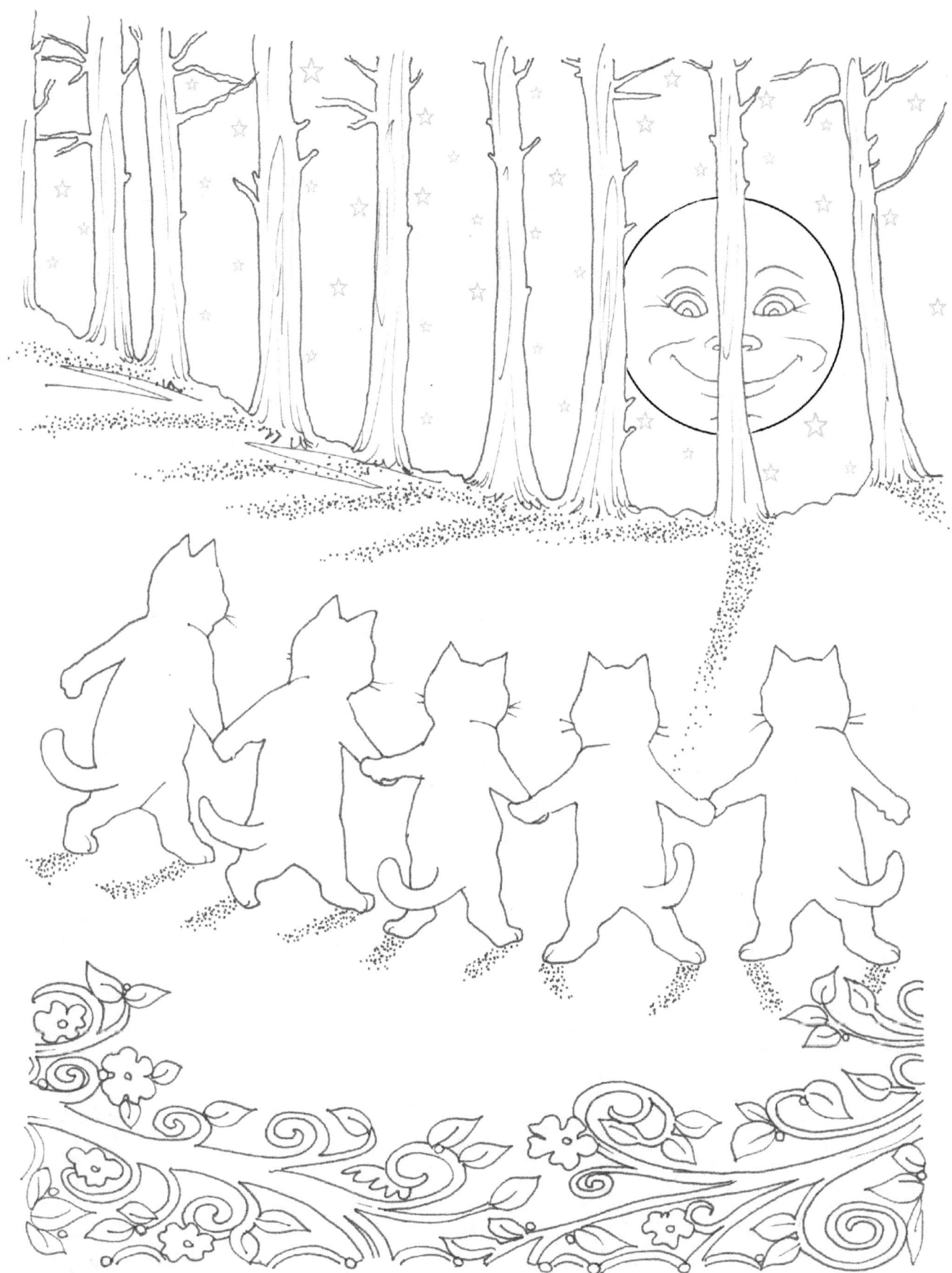

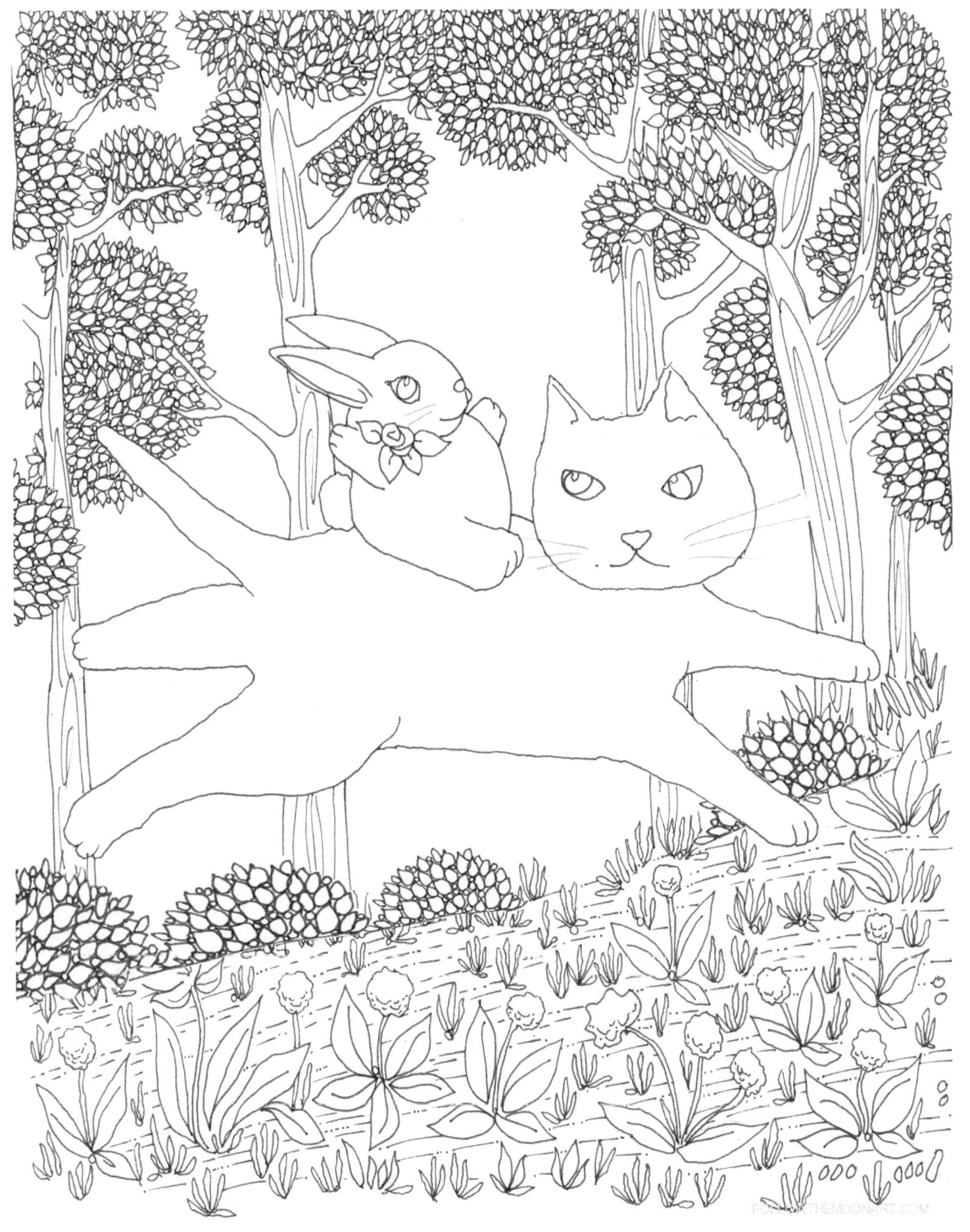

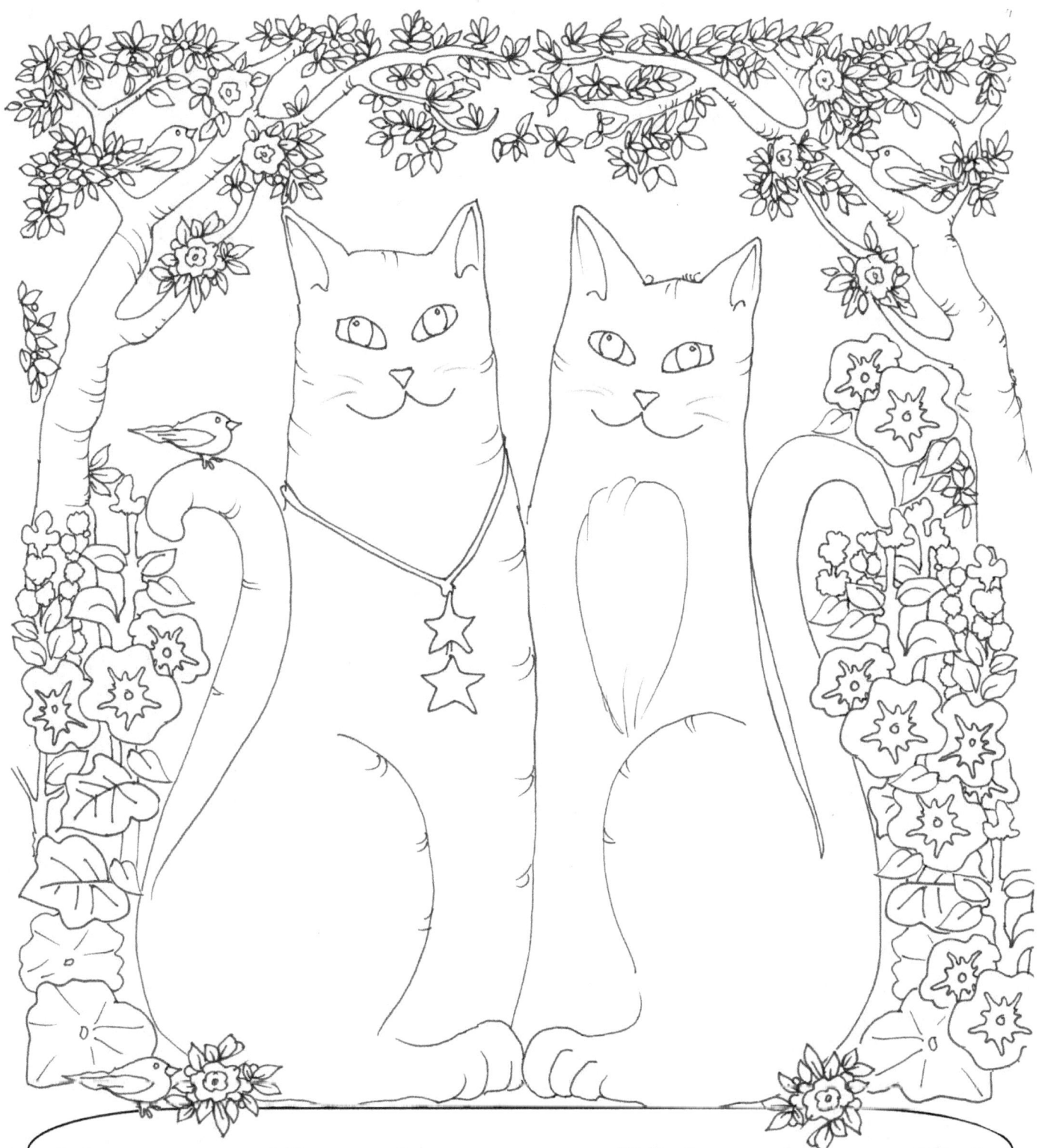

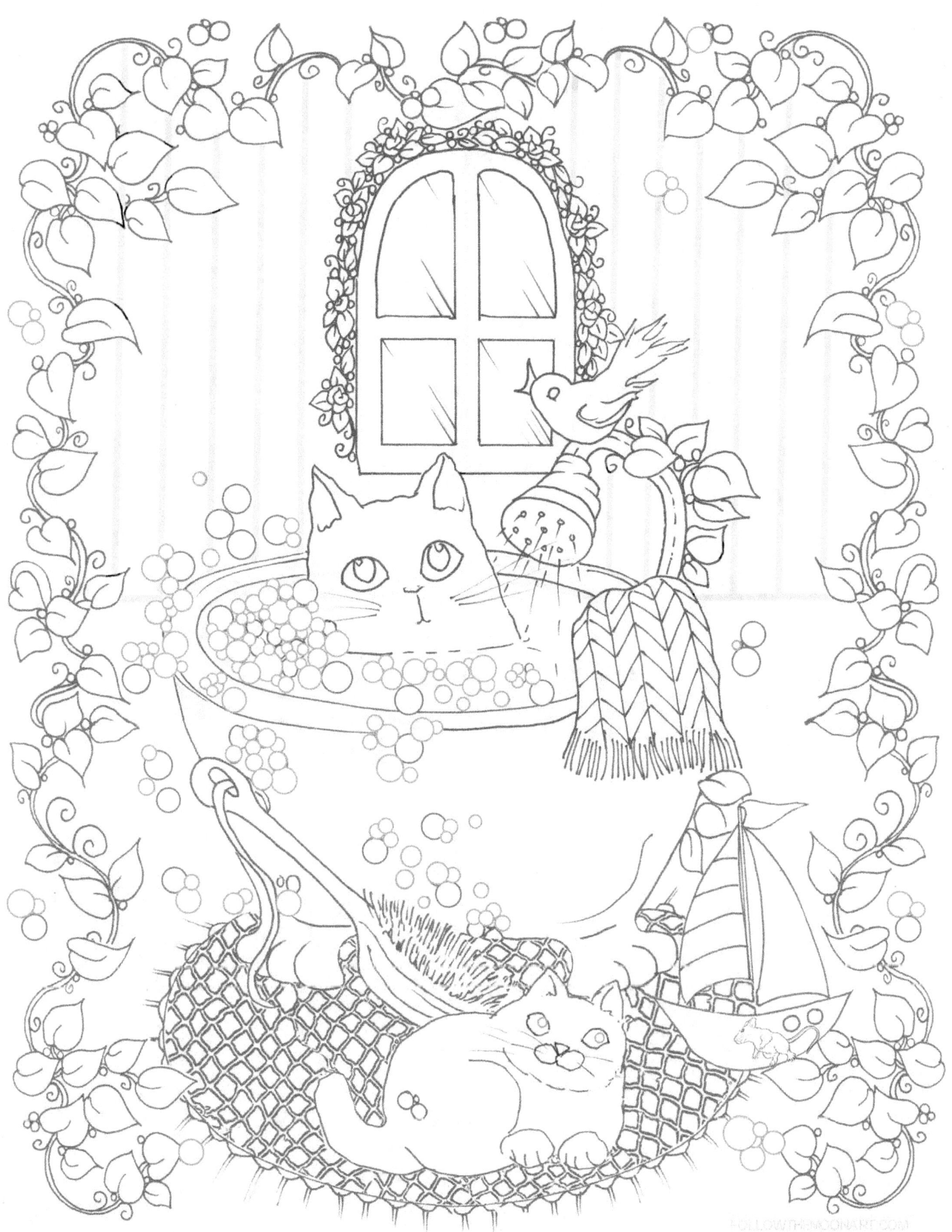

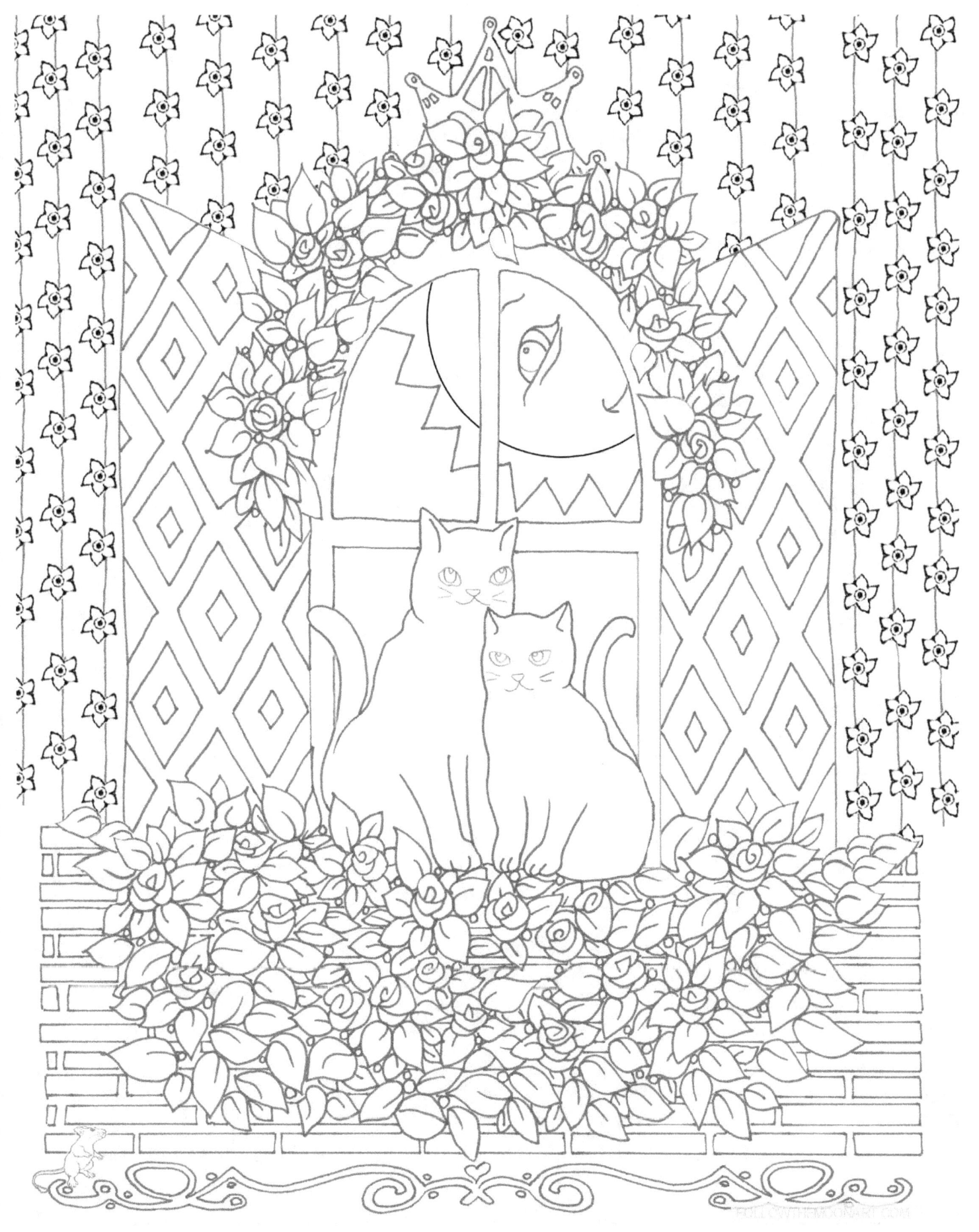

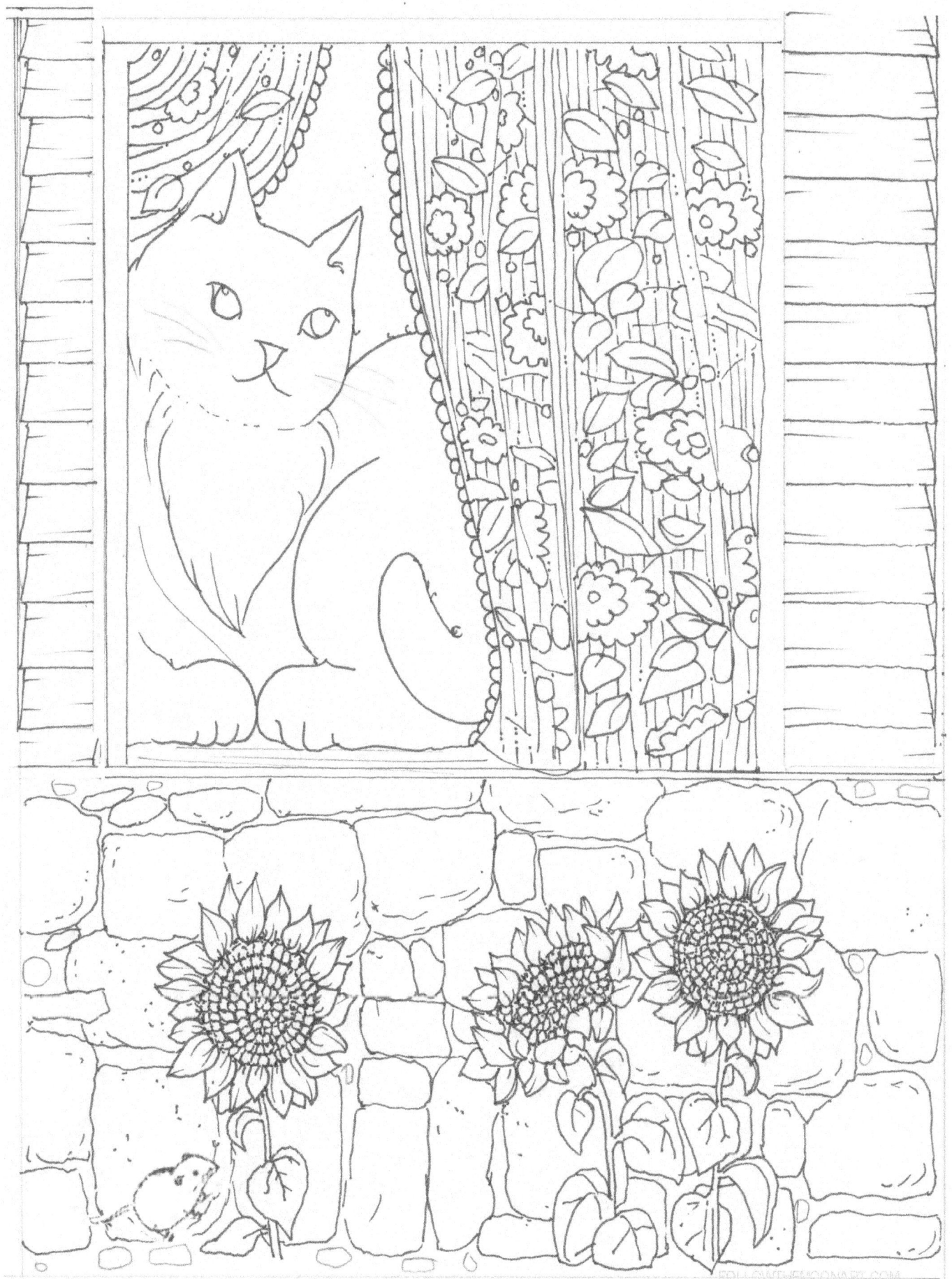

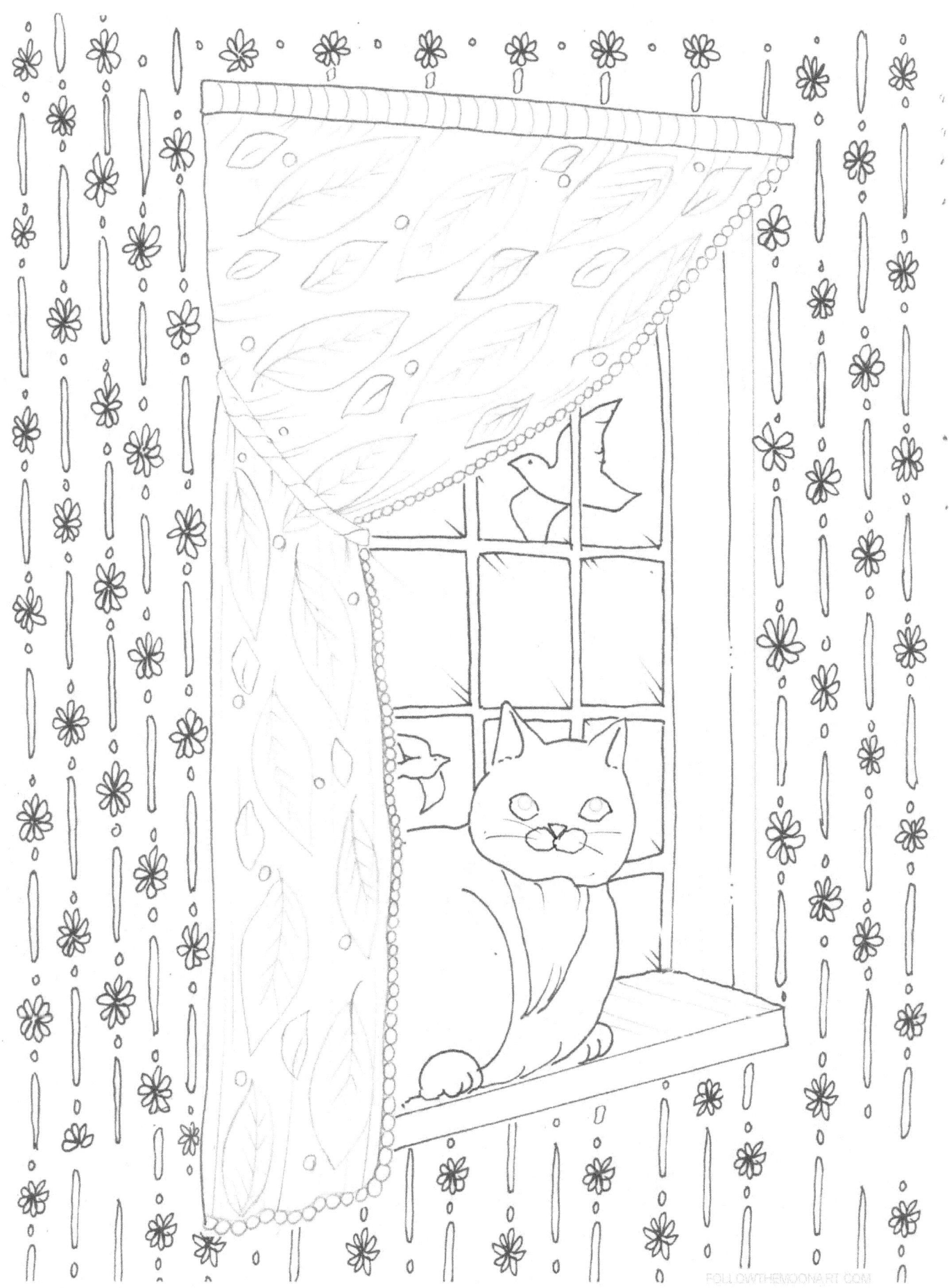

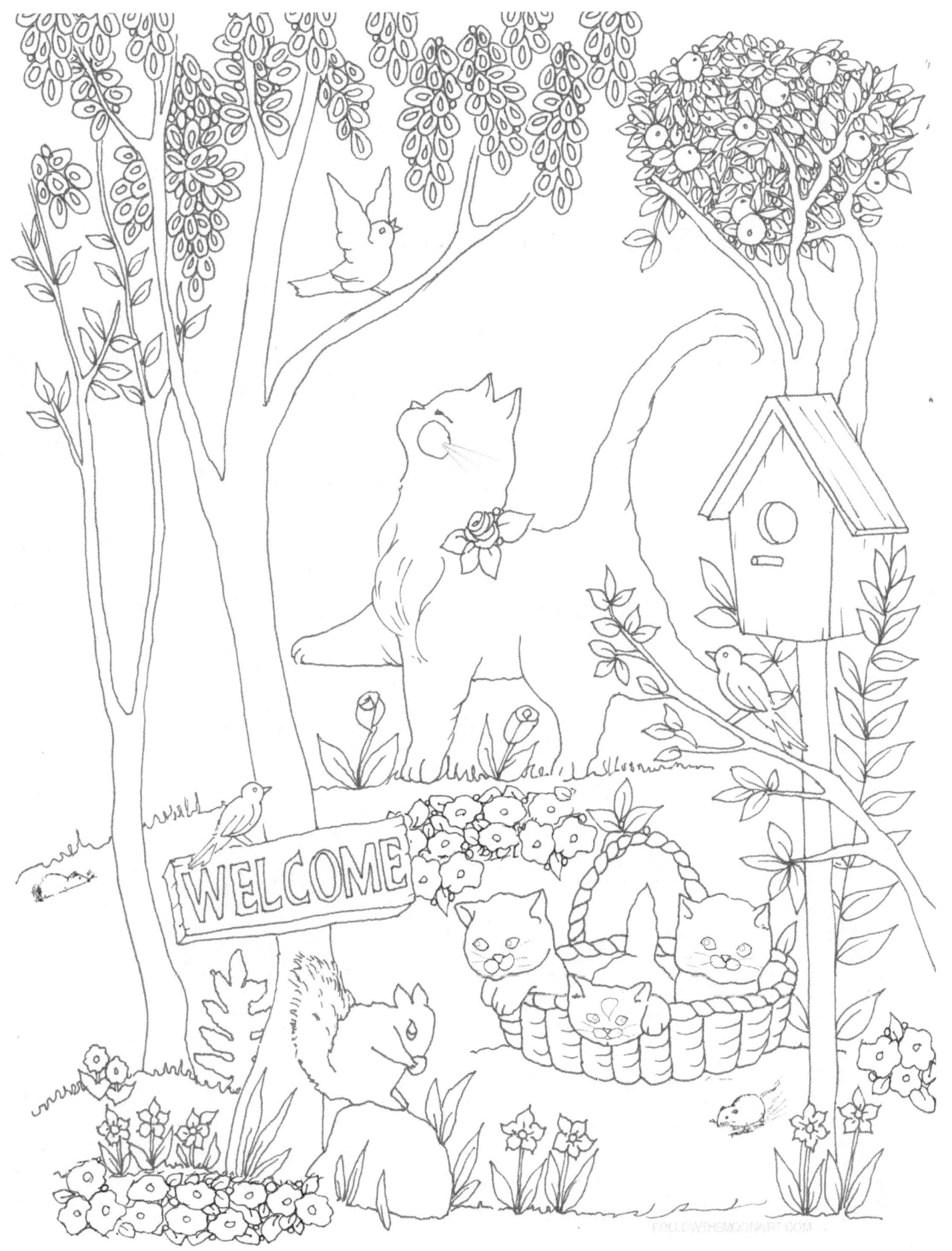

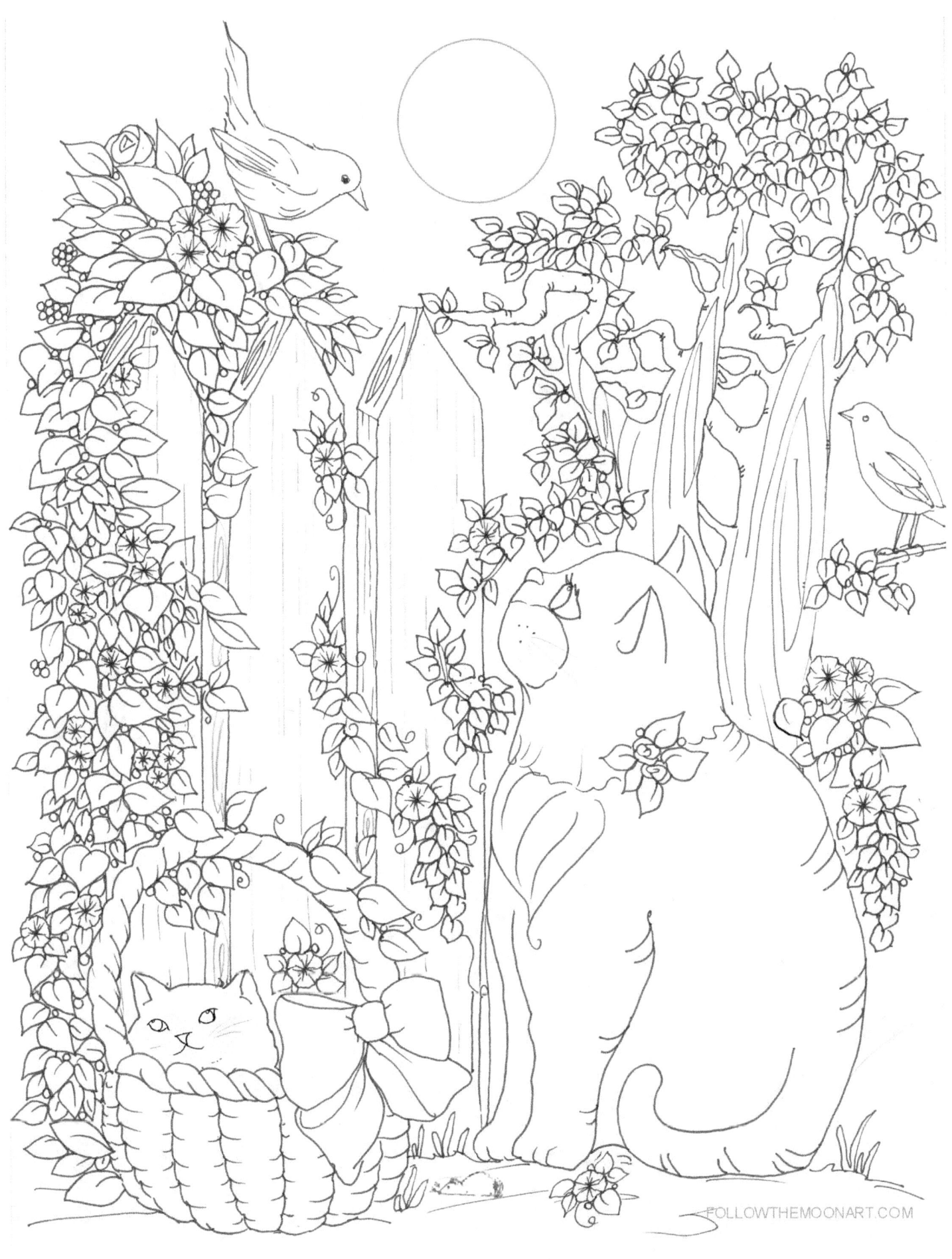

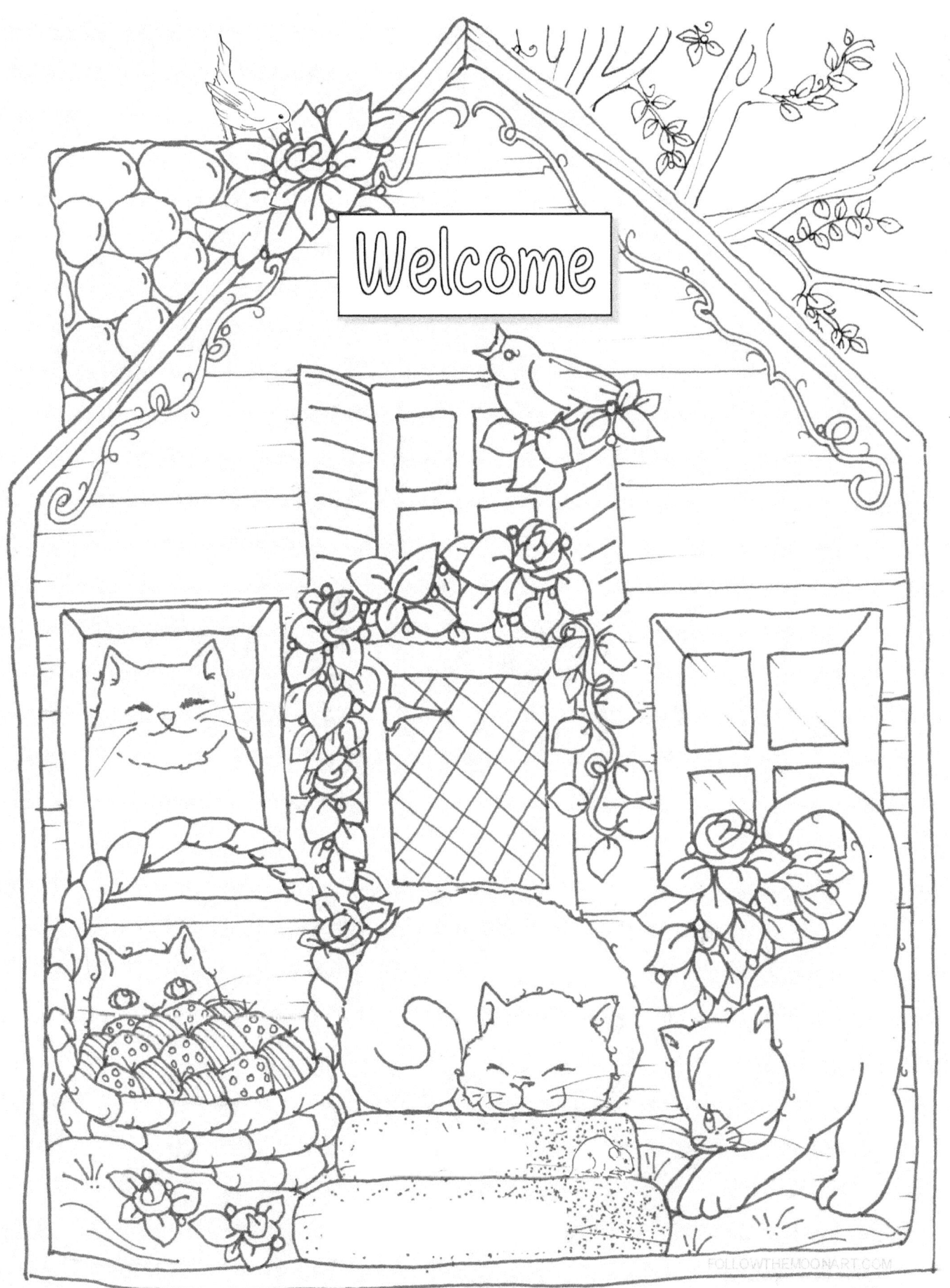

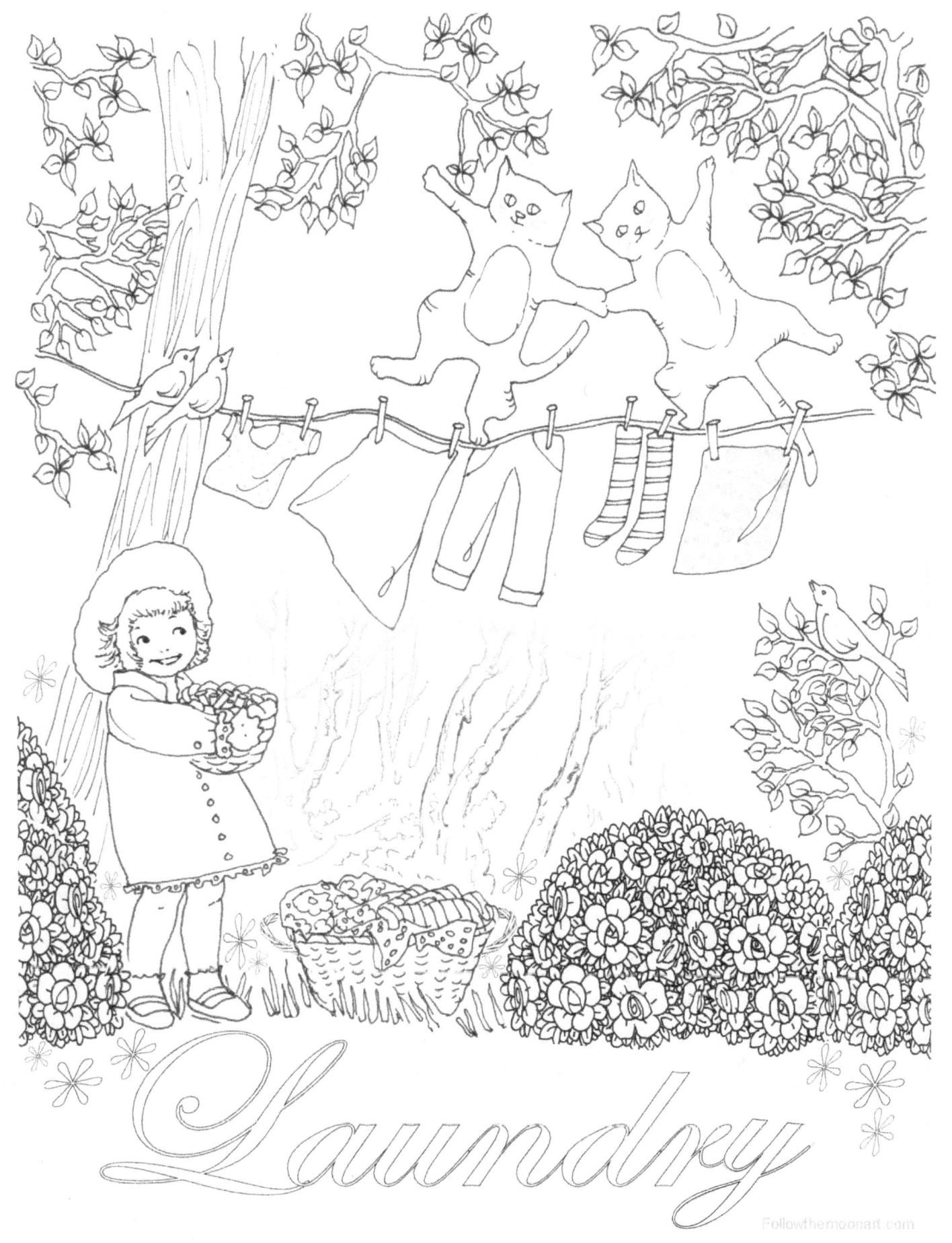

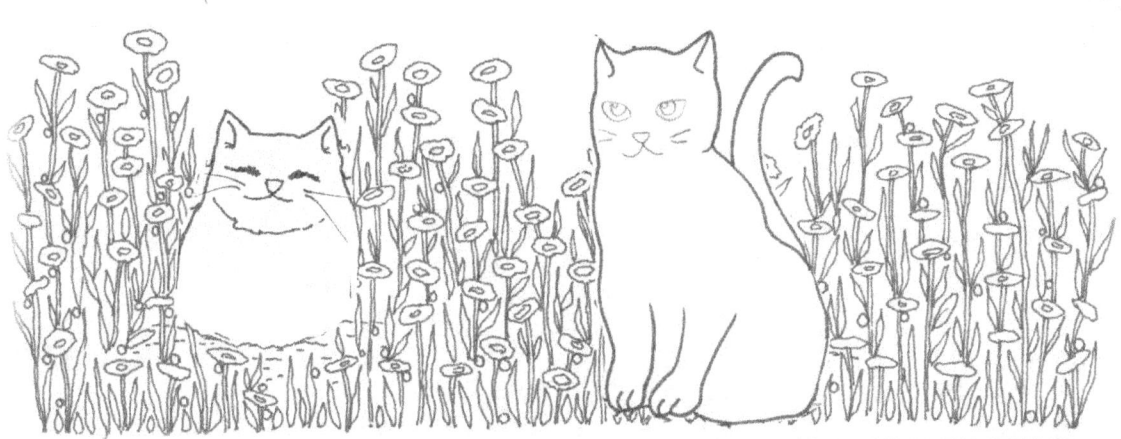

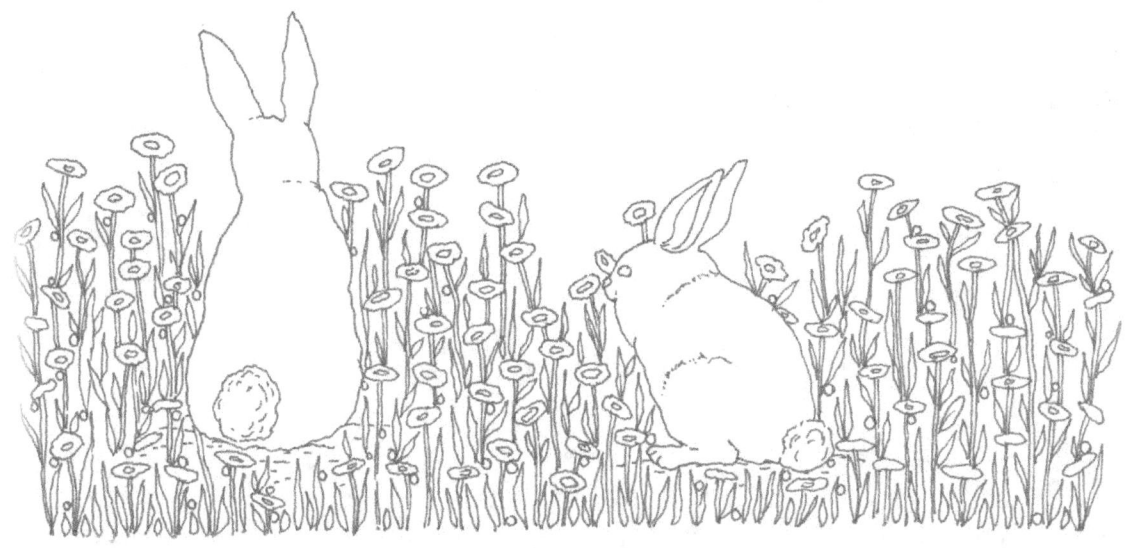